Magnificent Mehndi Designs
Coloring Book

Marty Noble

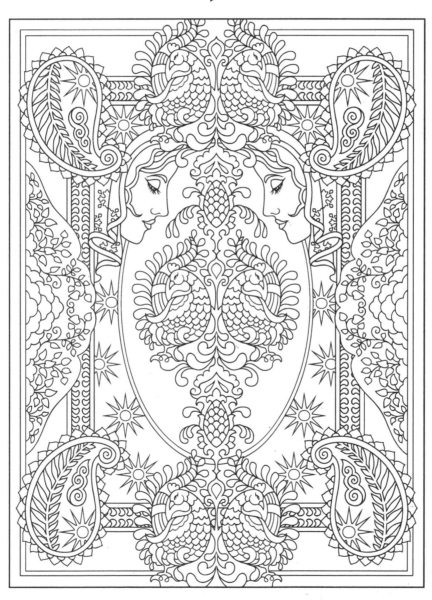

DOVER PUBLICATIONS, INC.
MINEOLA, NEW YORK

Mehndi is the traditional art of henna body painting that originated in India and the Middle East. The temporary designs are usually applied to a woman's hands and feet, but for special occasions men may also wear them. At weddings, for example, both the bride and groom may be decorated, as well as others in the wedding party. As you can see in this collection by artist Marty Noble, the designs are often elegantly detailed and quite beautiful. Mehndi artists work with a dye made from dried, ground henna leaves (and sometimes with a mixture of other ingredients such as tea, coffee, lemon, wine sugar, syrup, egg, yogurt, tamarind, cloves, or titanium powder). The results look very much like intricate tattoos—but have the advantage of not demanding a lifelong commitment. Unlike tattoos, mehndi designs wear off in about two weeks.

Bibliographical Note
Magnificent Mehndi Designs Coloring Book is a new work, first published by Dover Publications, Inc., in 2015.

International Standard Book Number
ISBN-13: 978-0-486-79791-5
ISBN-10: 0-486-79791-0

Manufactured in the United States by RR Donnelley
79791006 2015
www.doverpublications.com

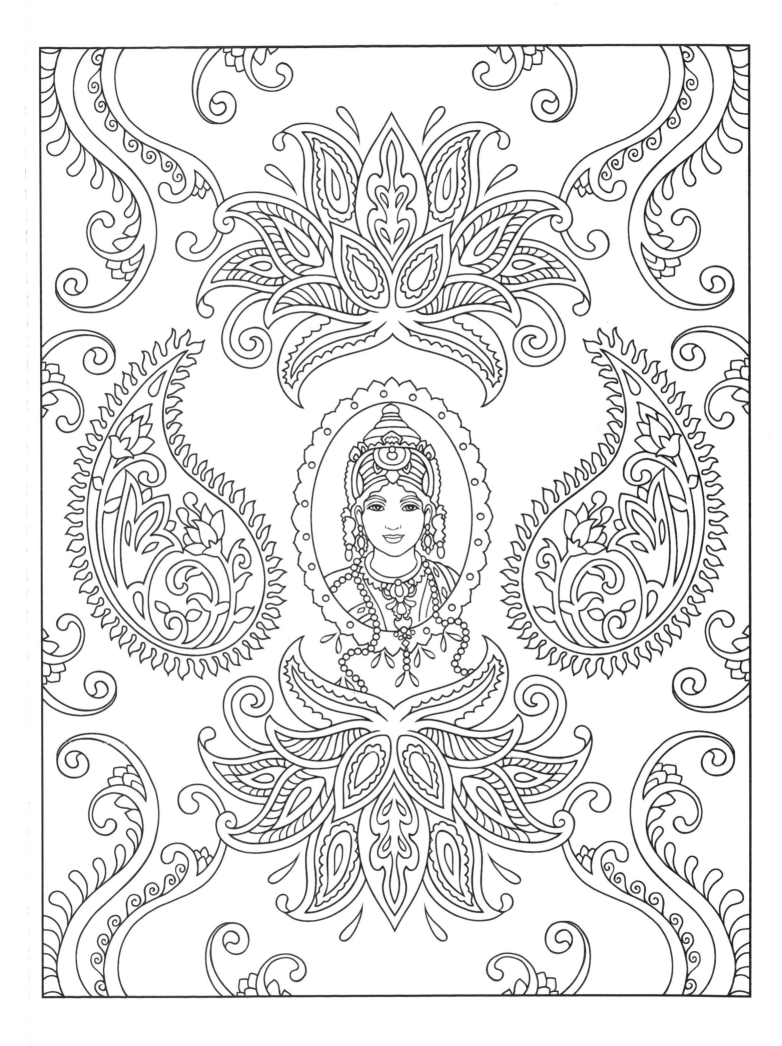

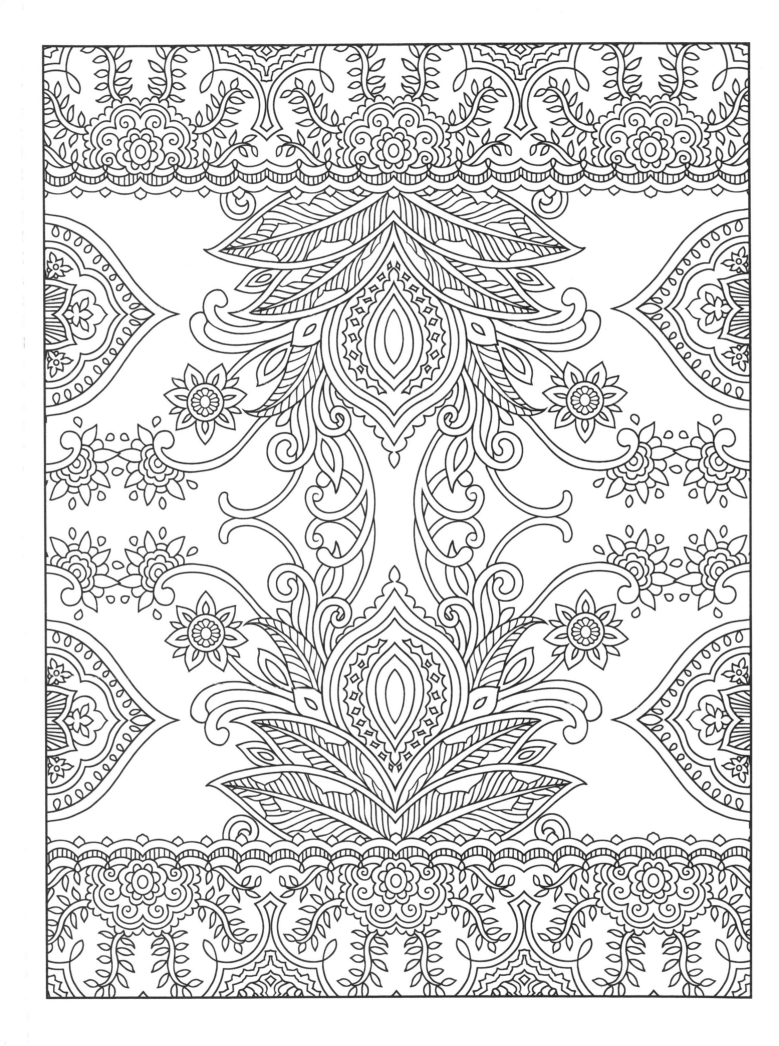

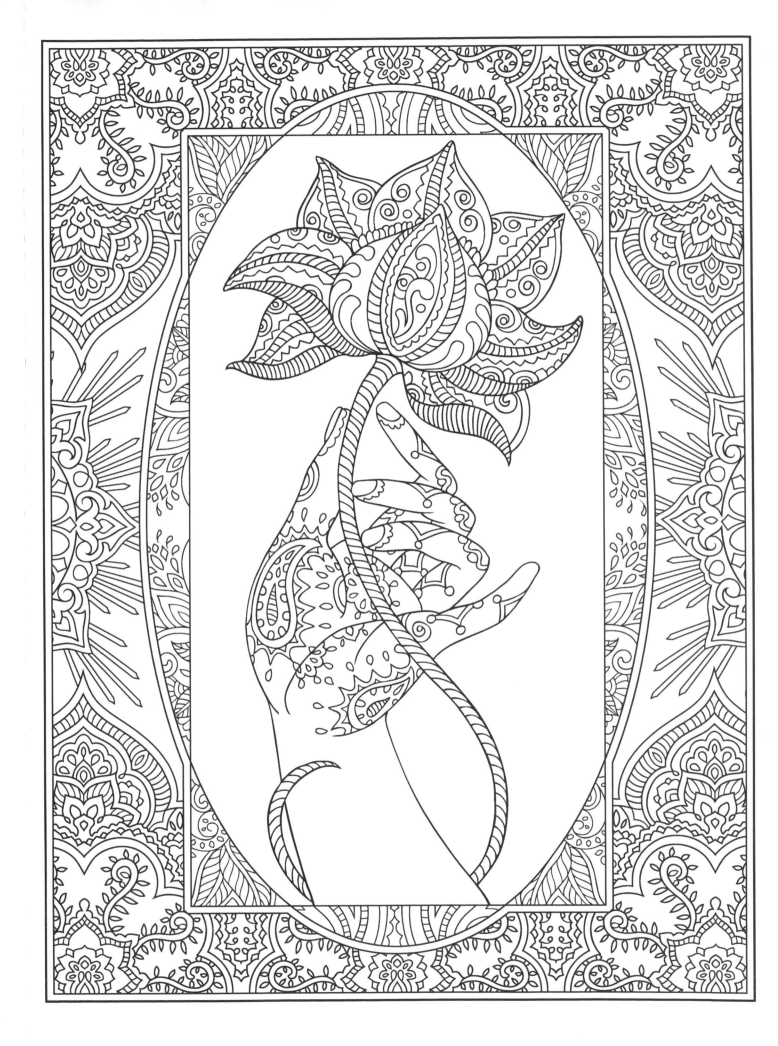

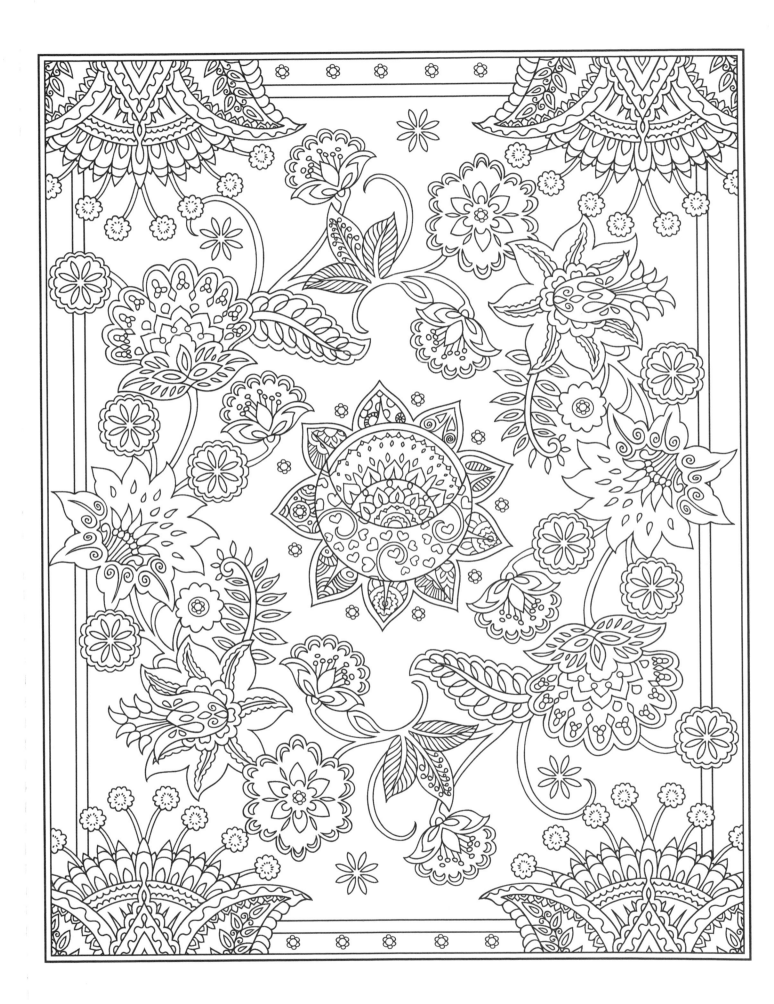

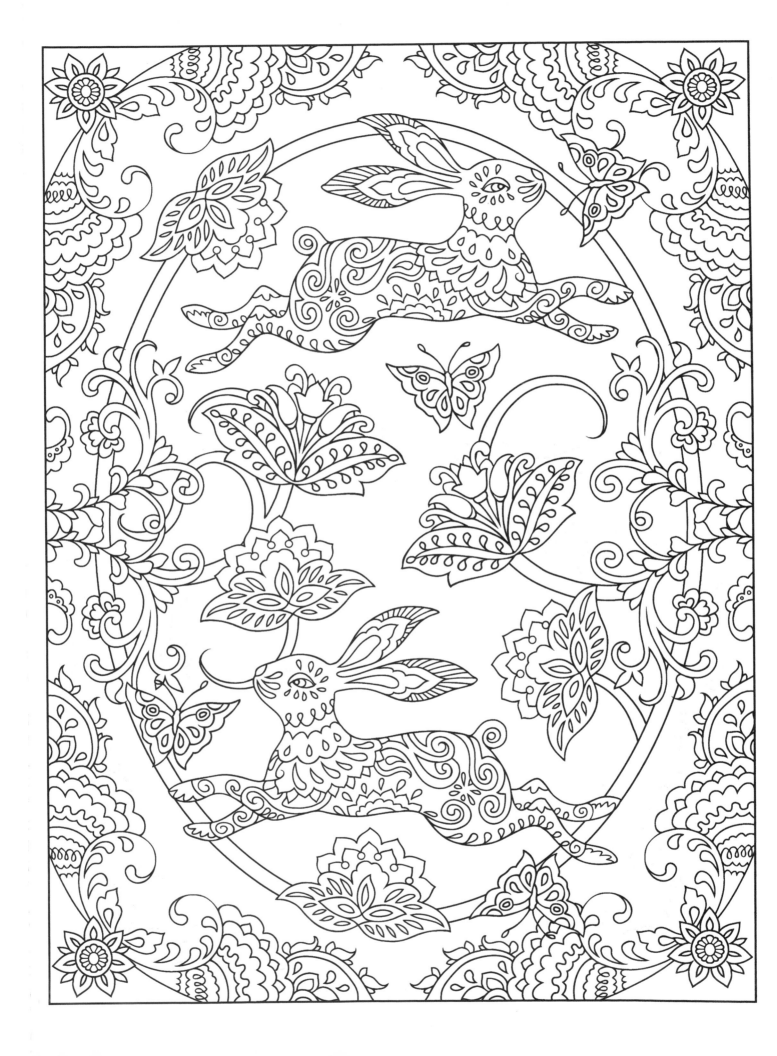

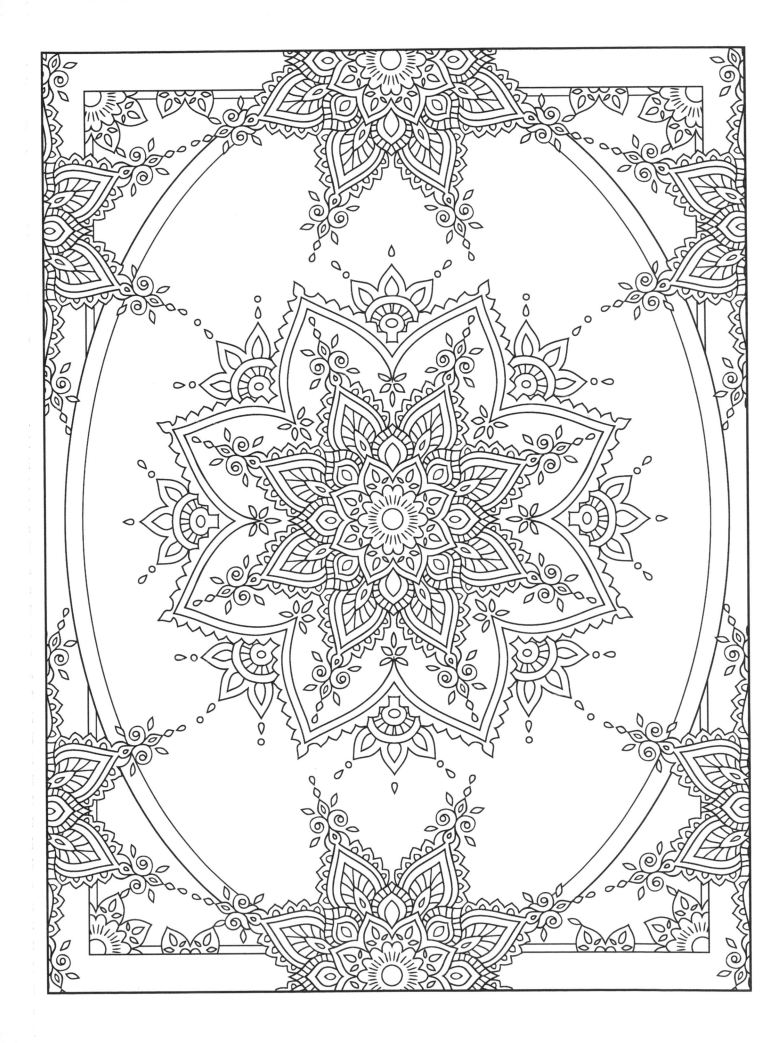

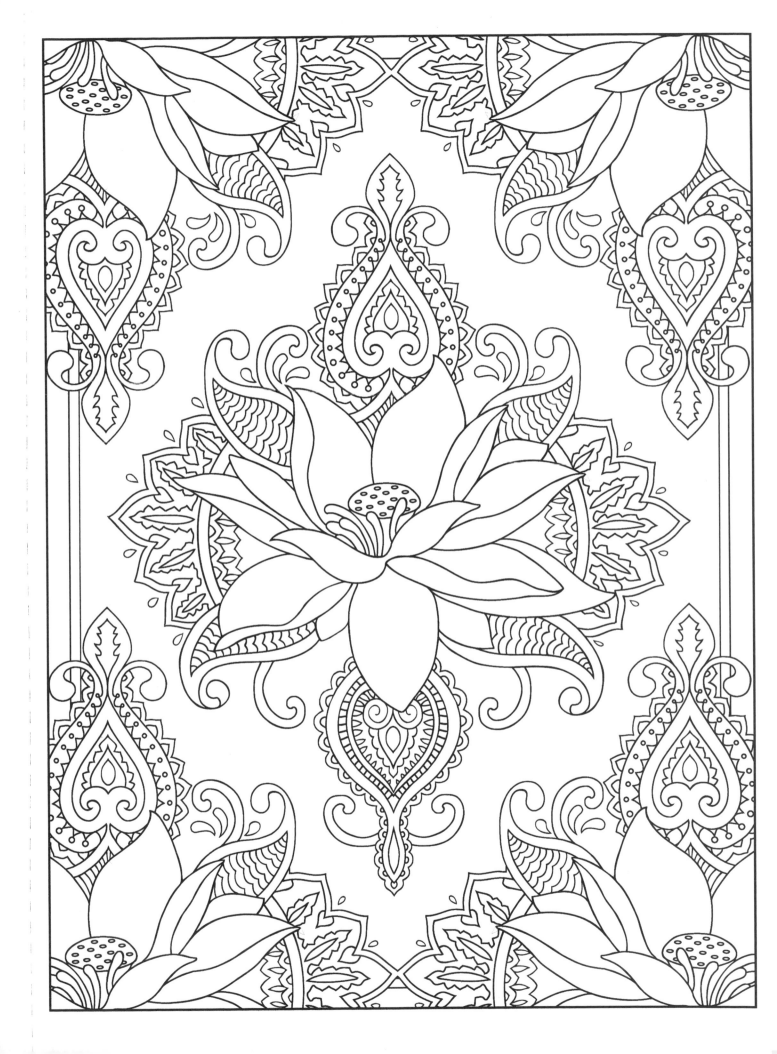

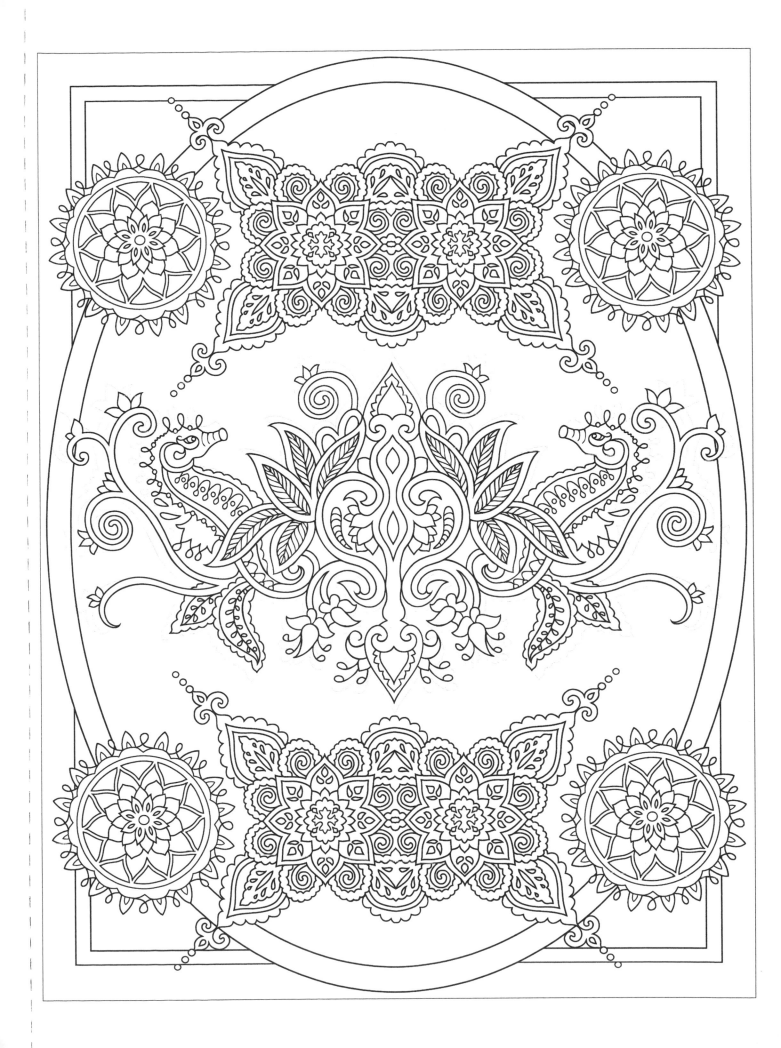

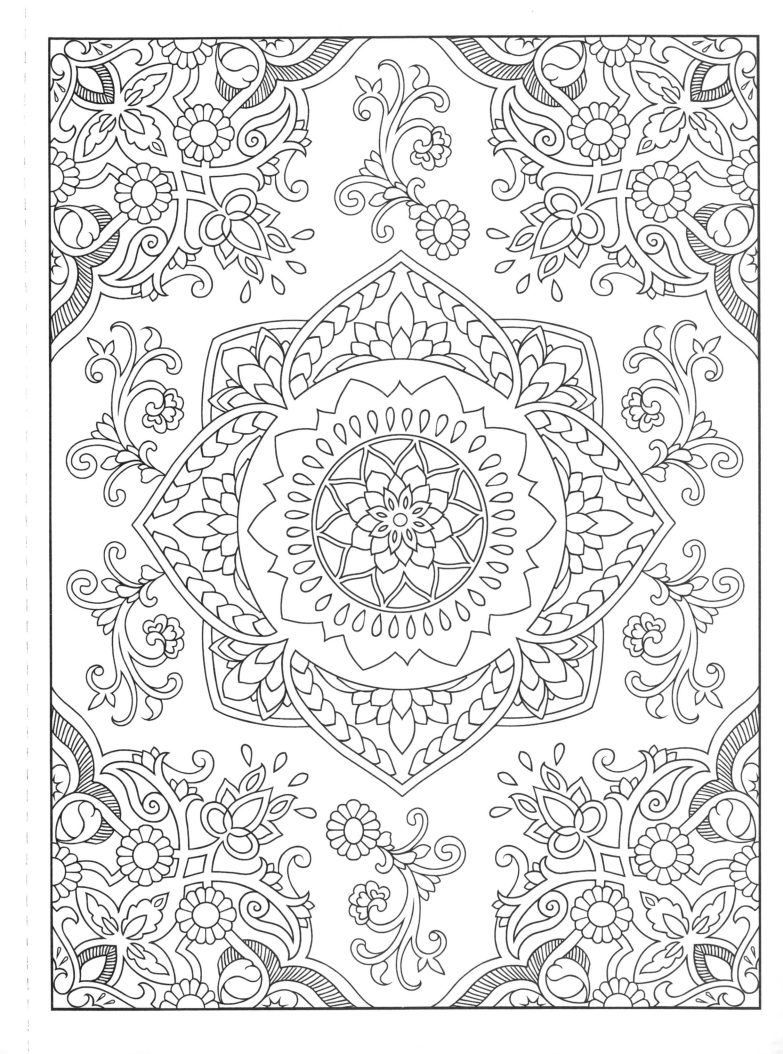

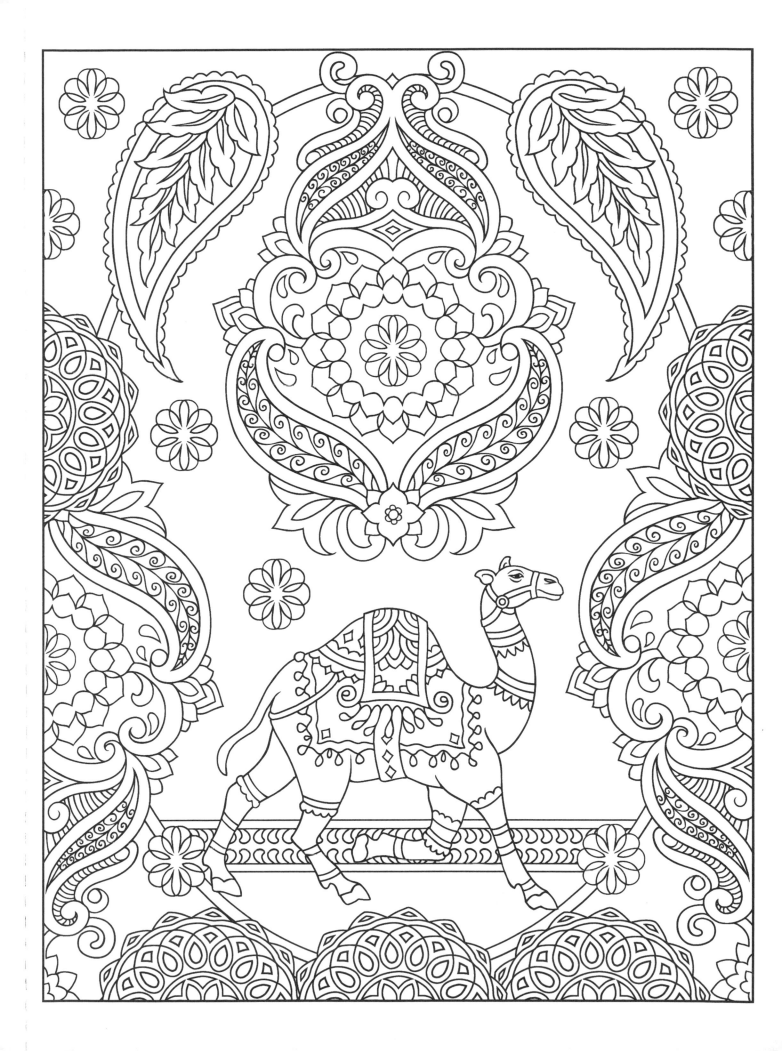

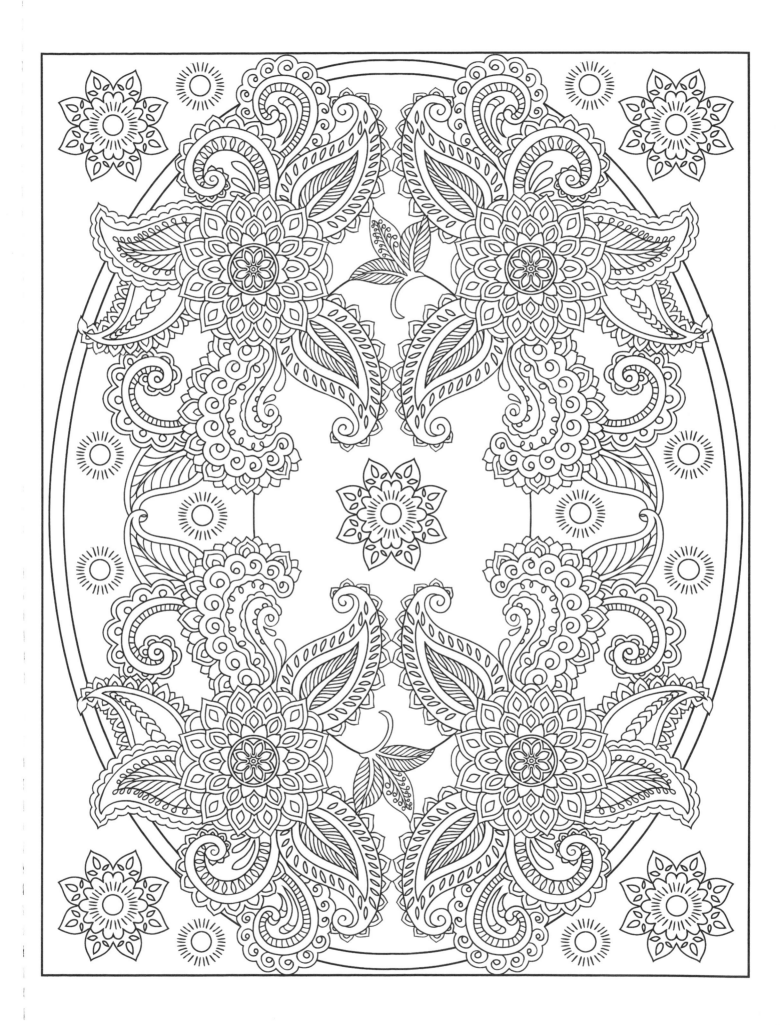

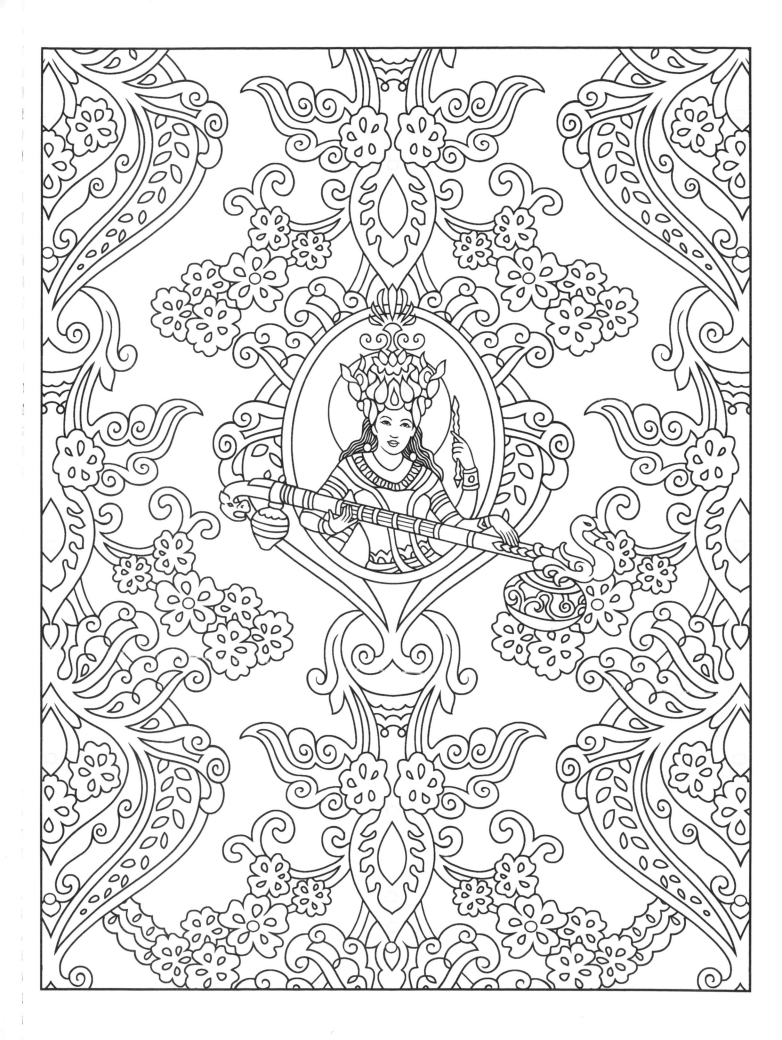

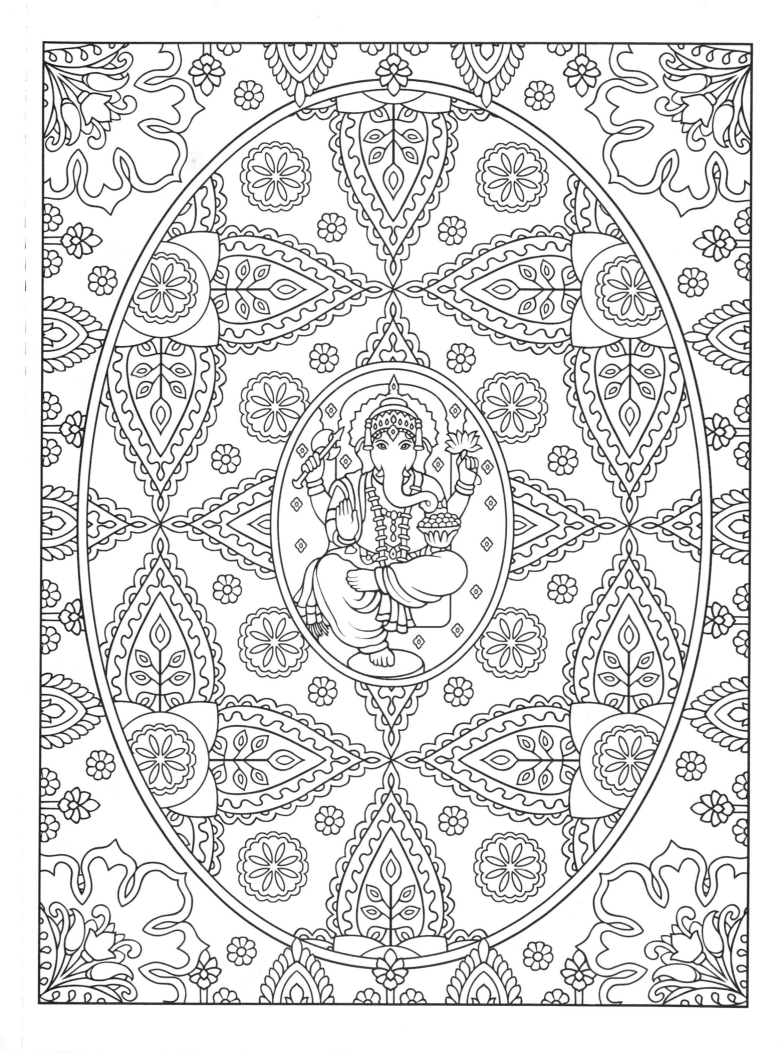

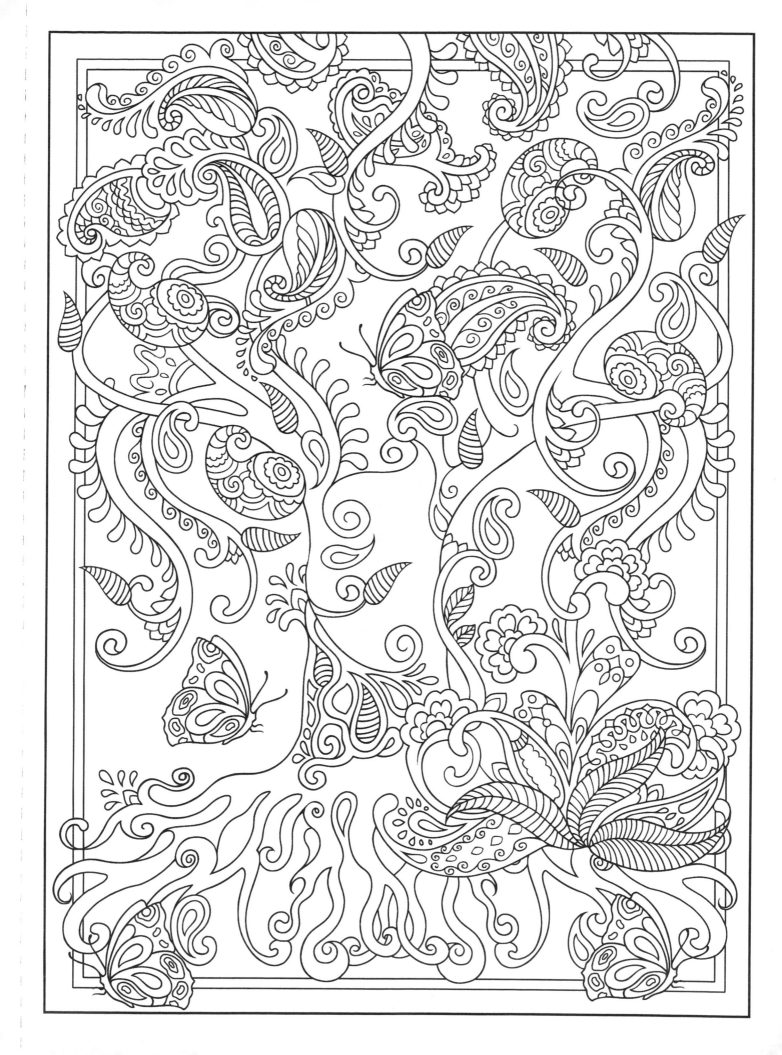

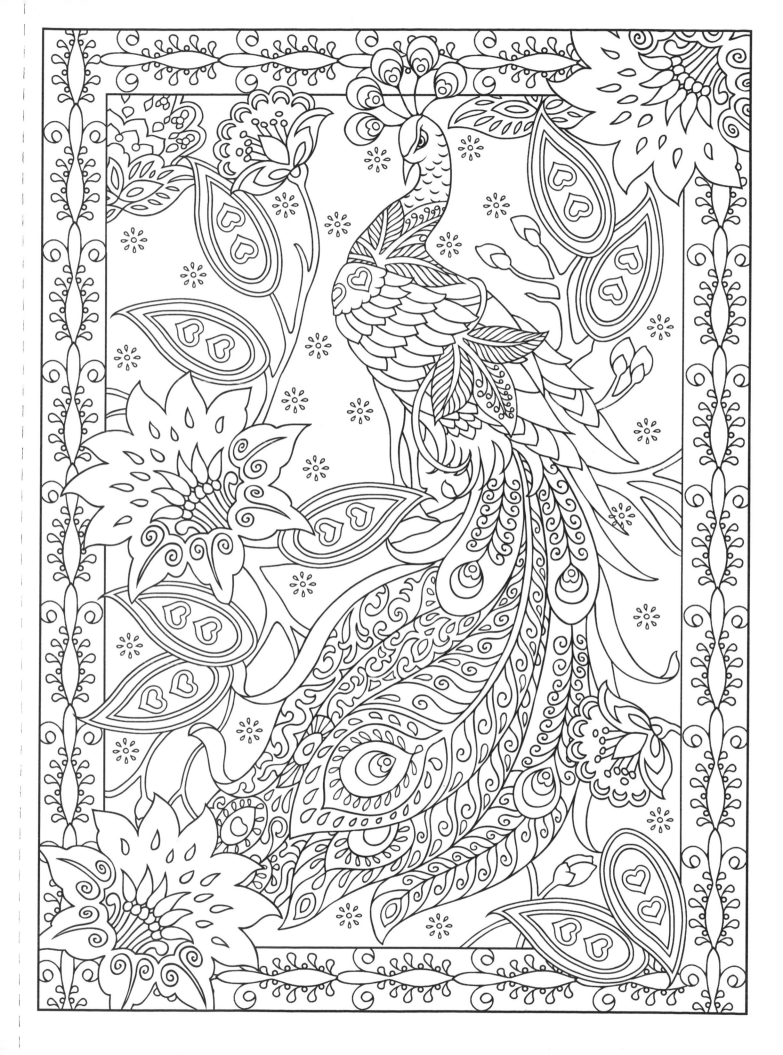

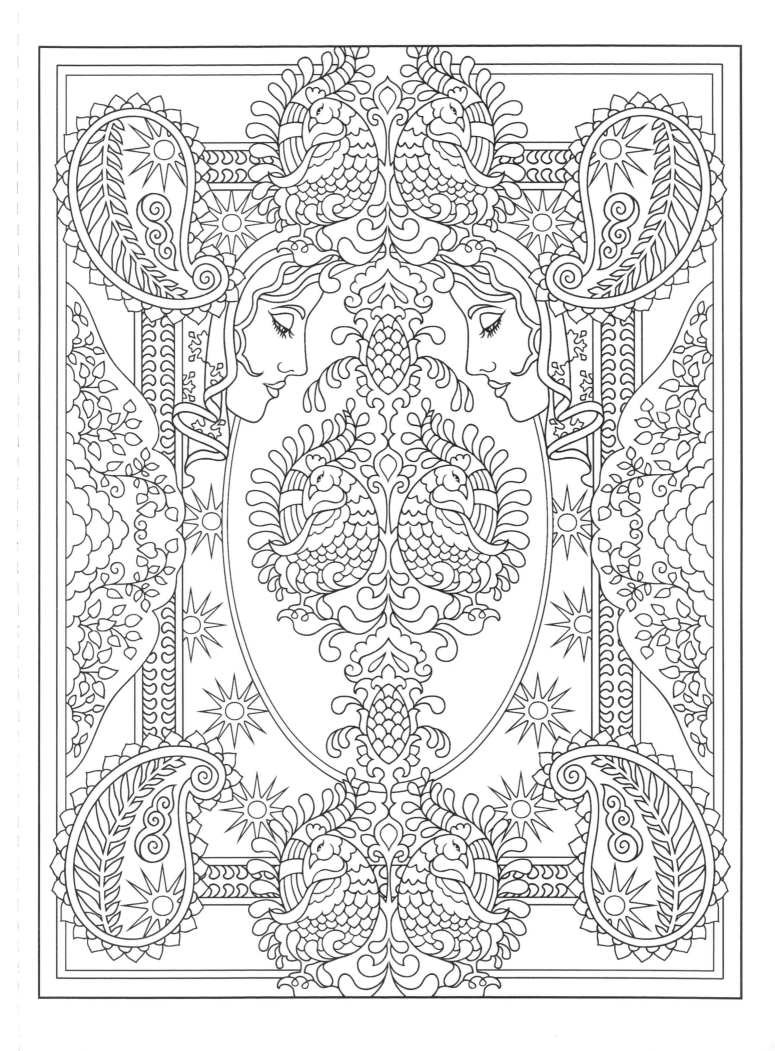

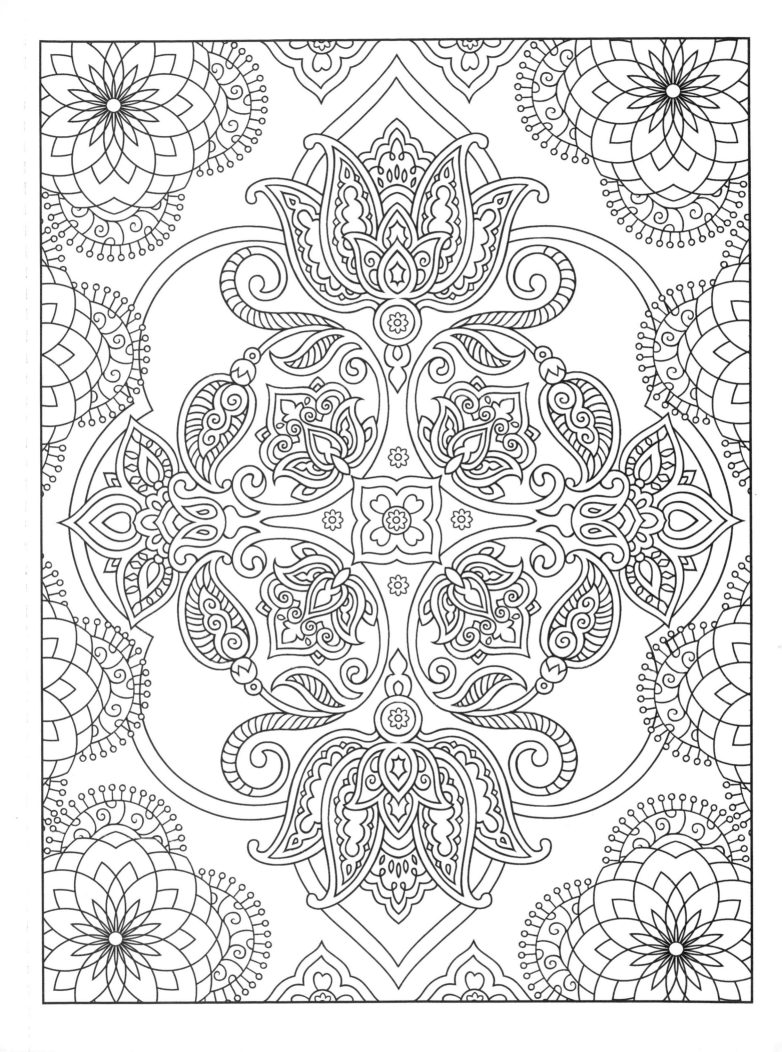

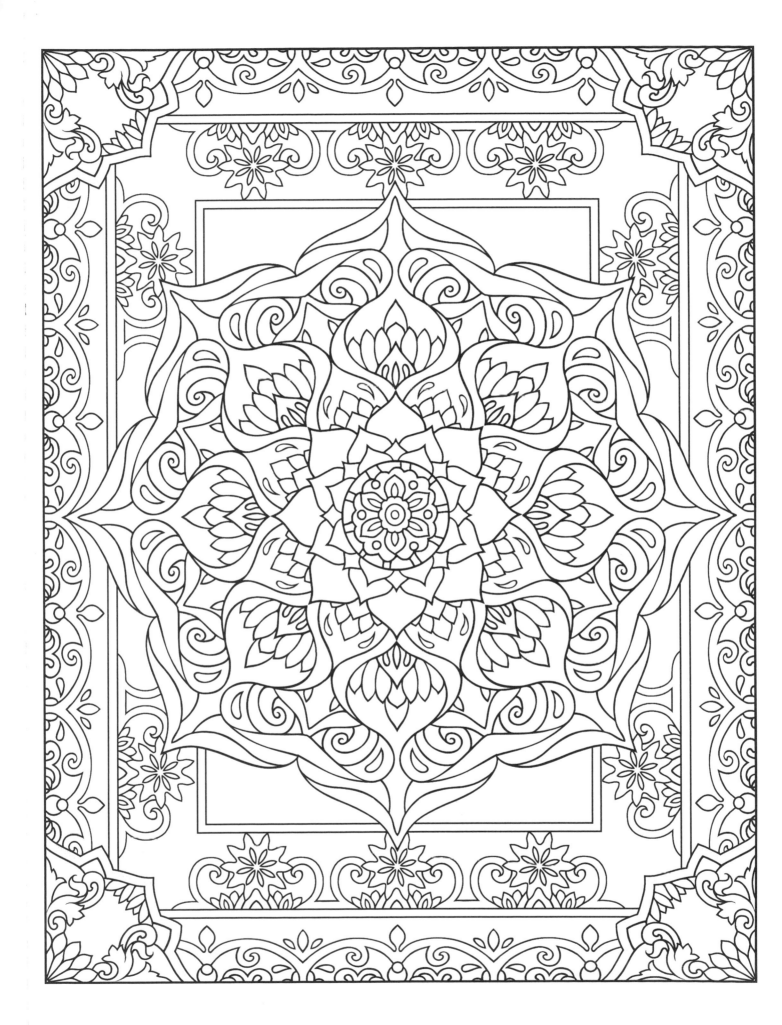

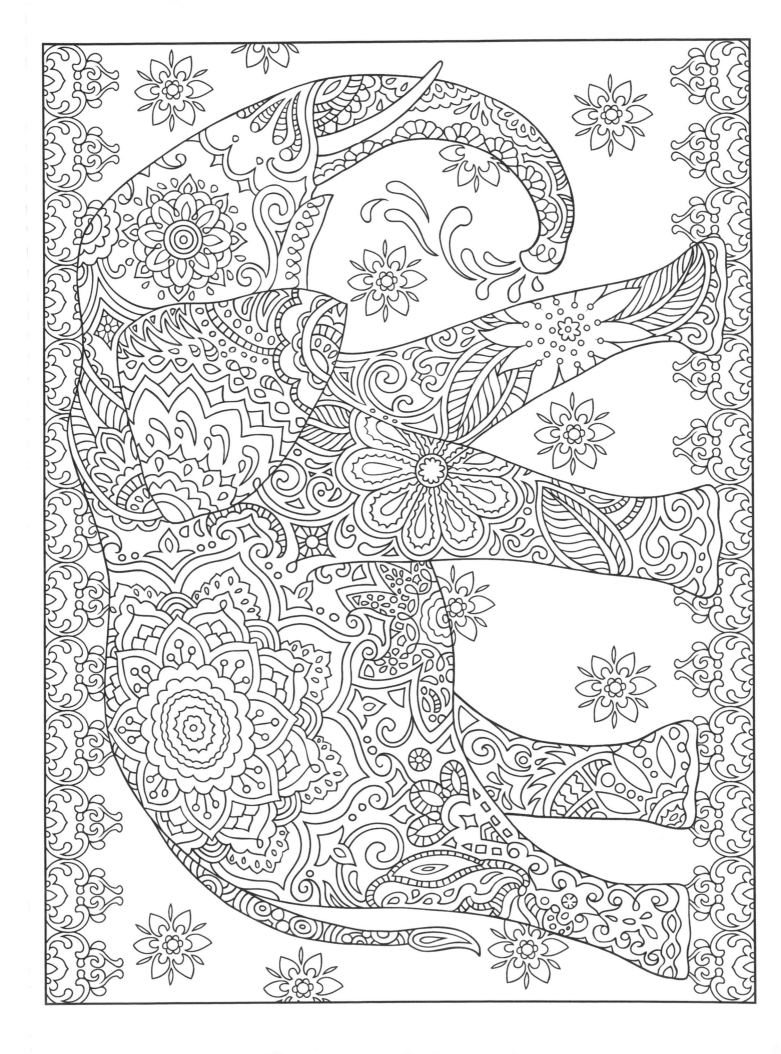

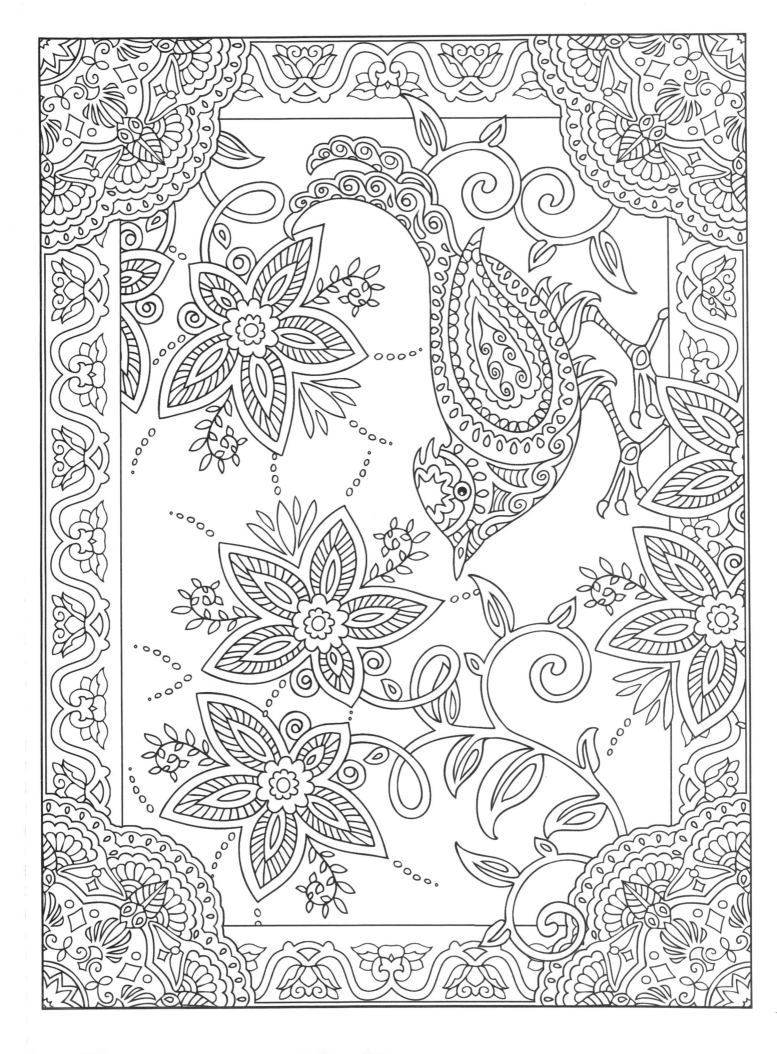

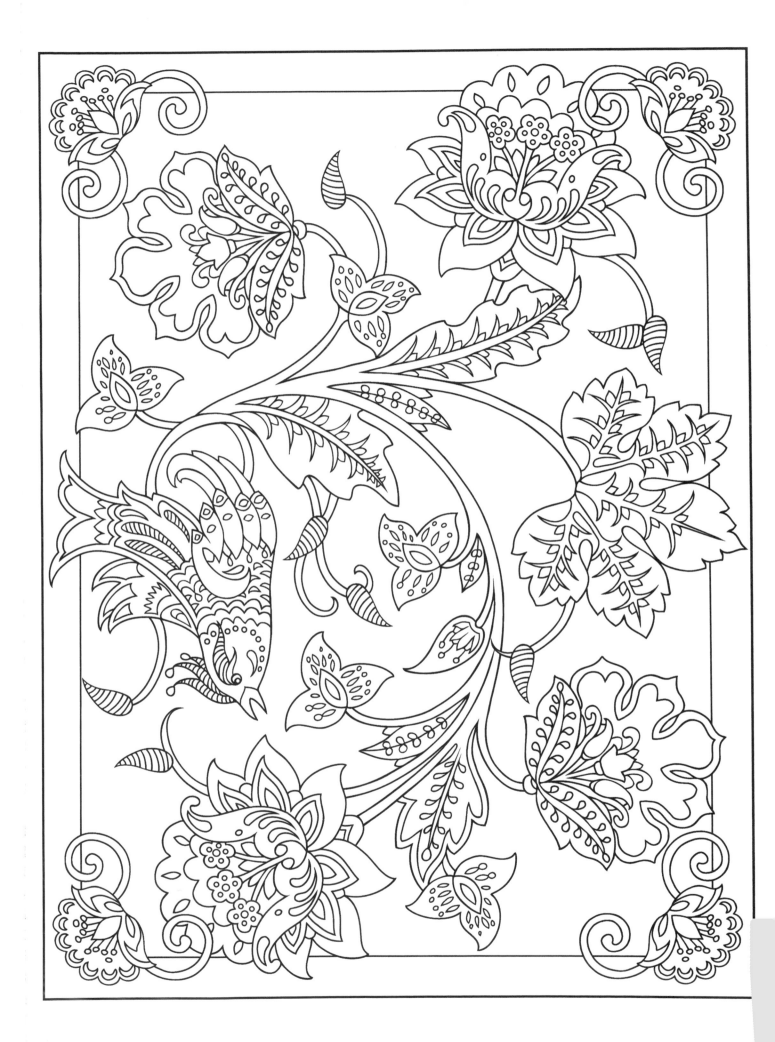

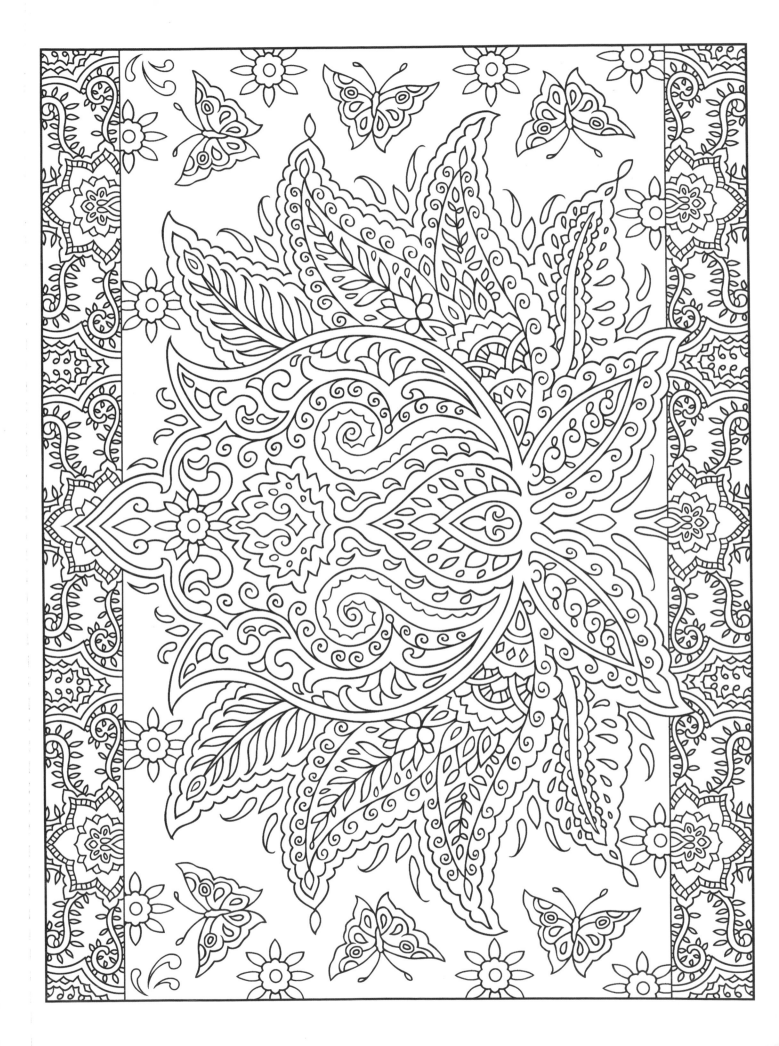

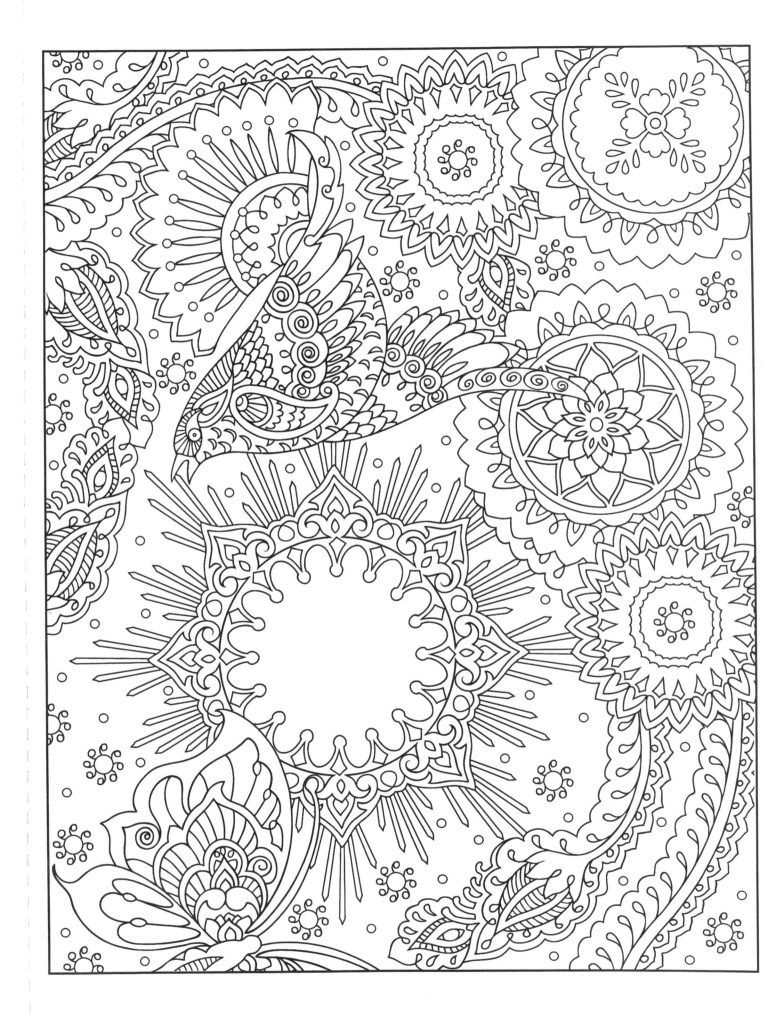

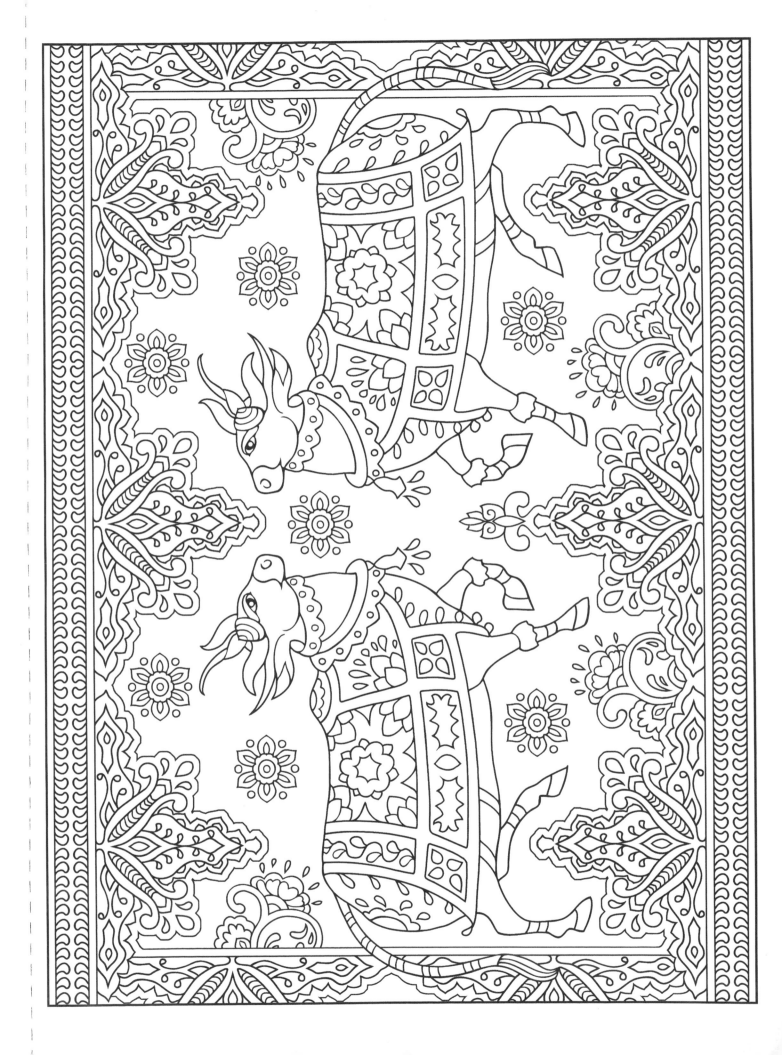

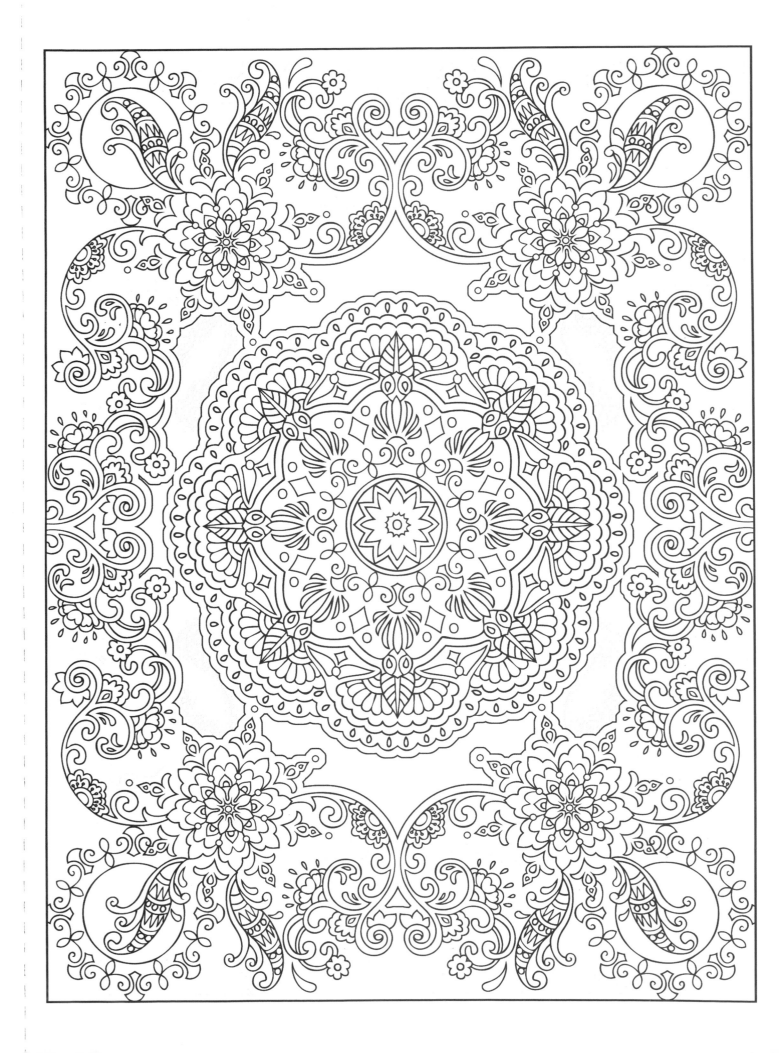

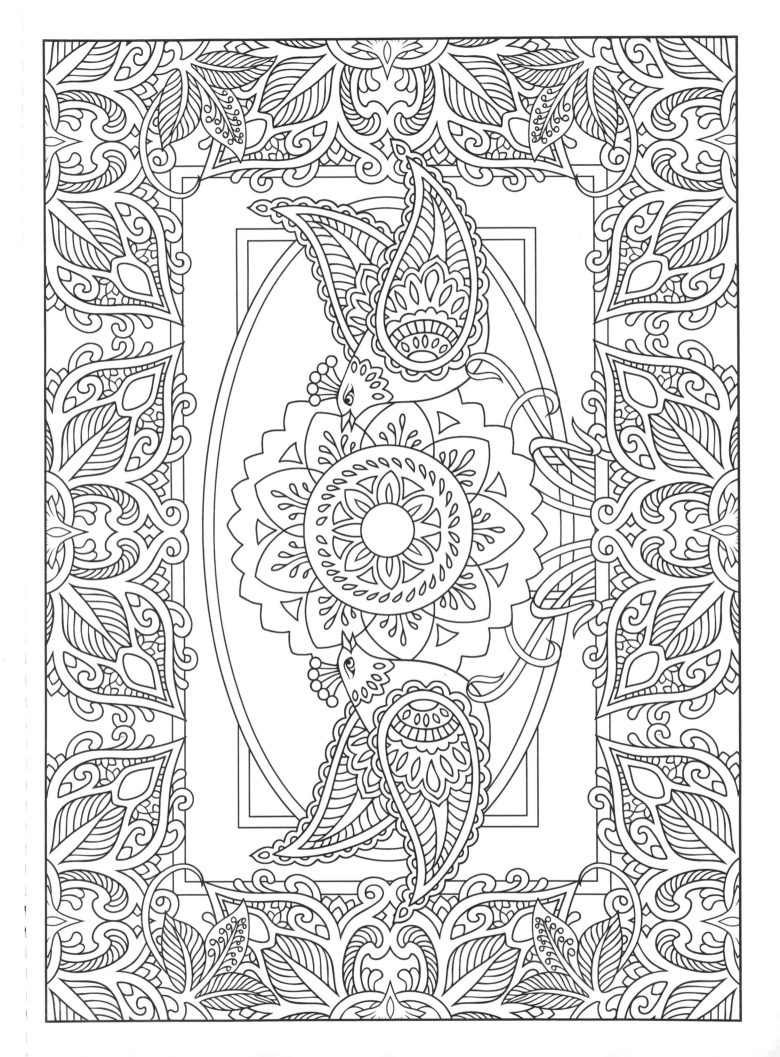

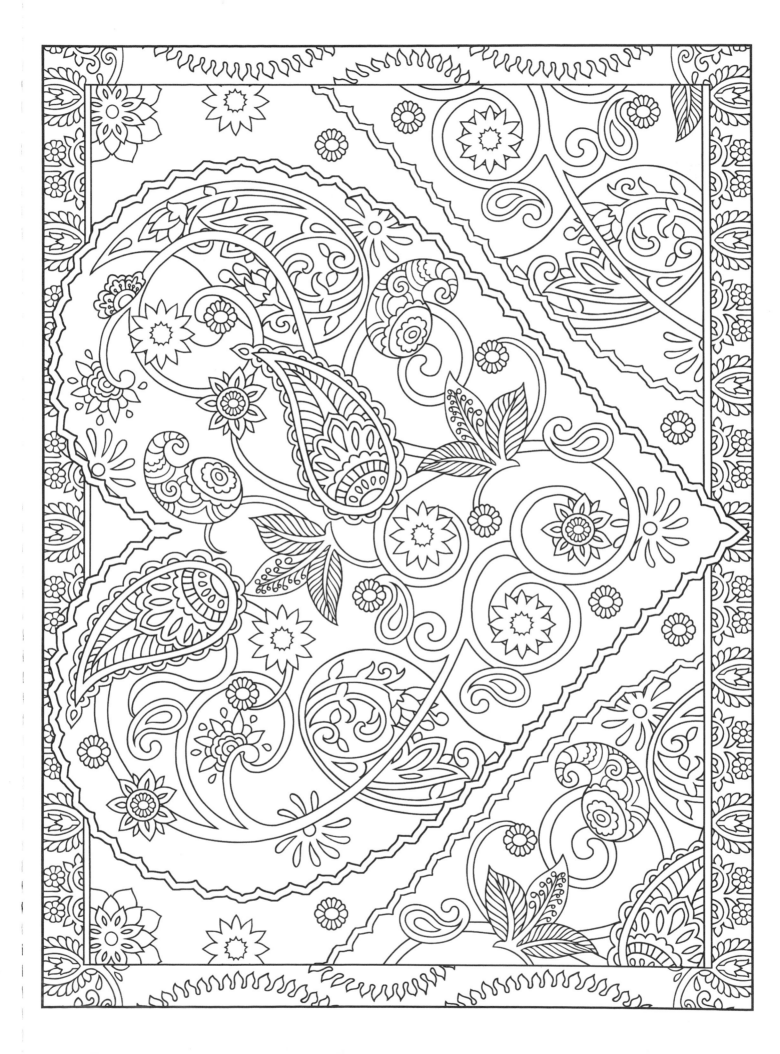

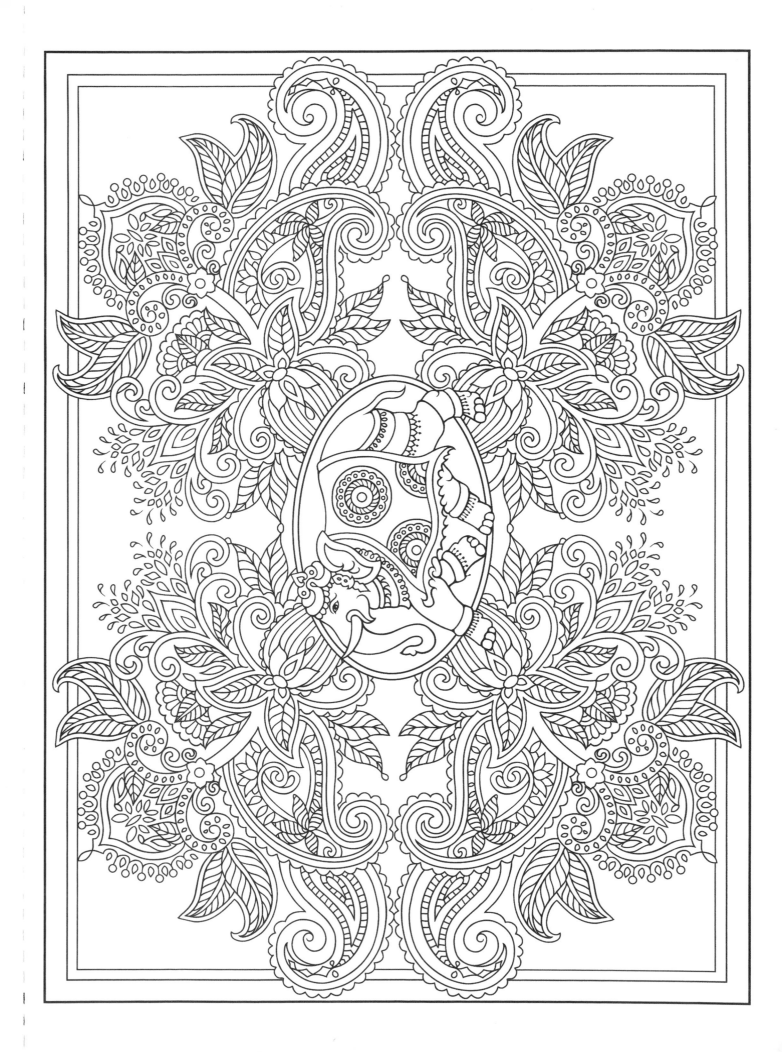

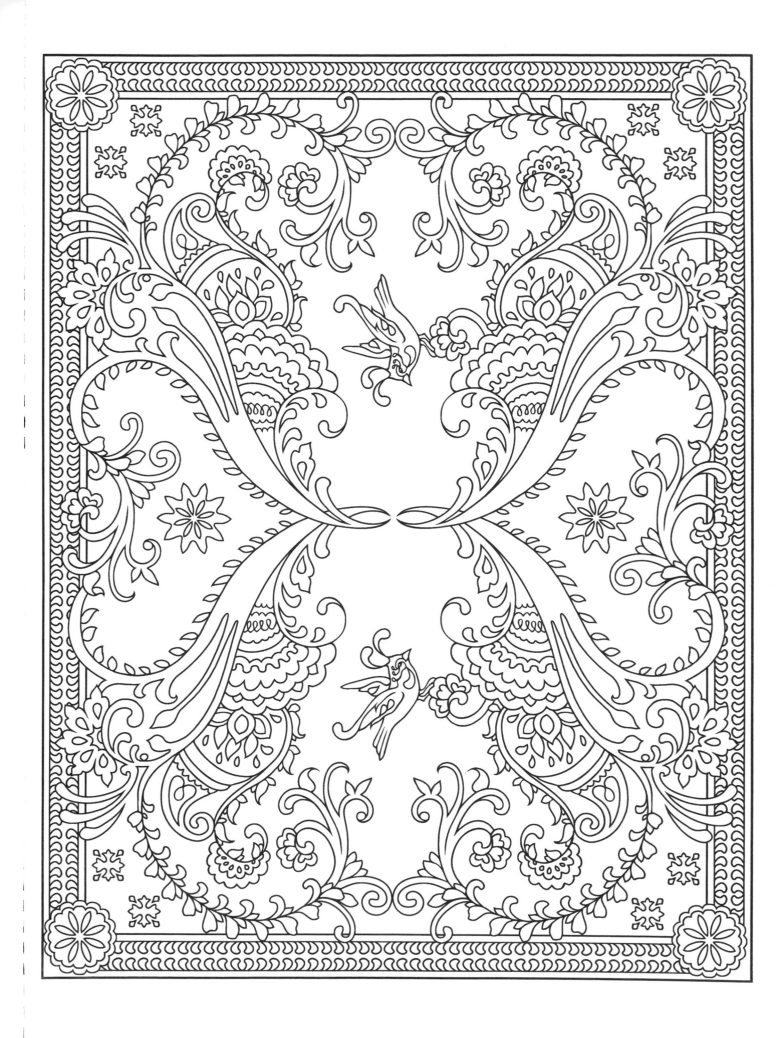

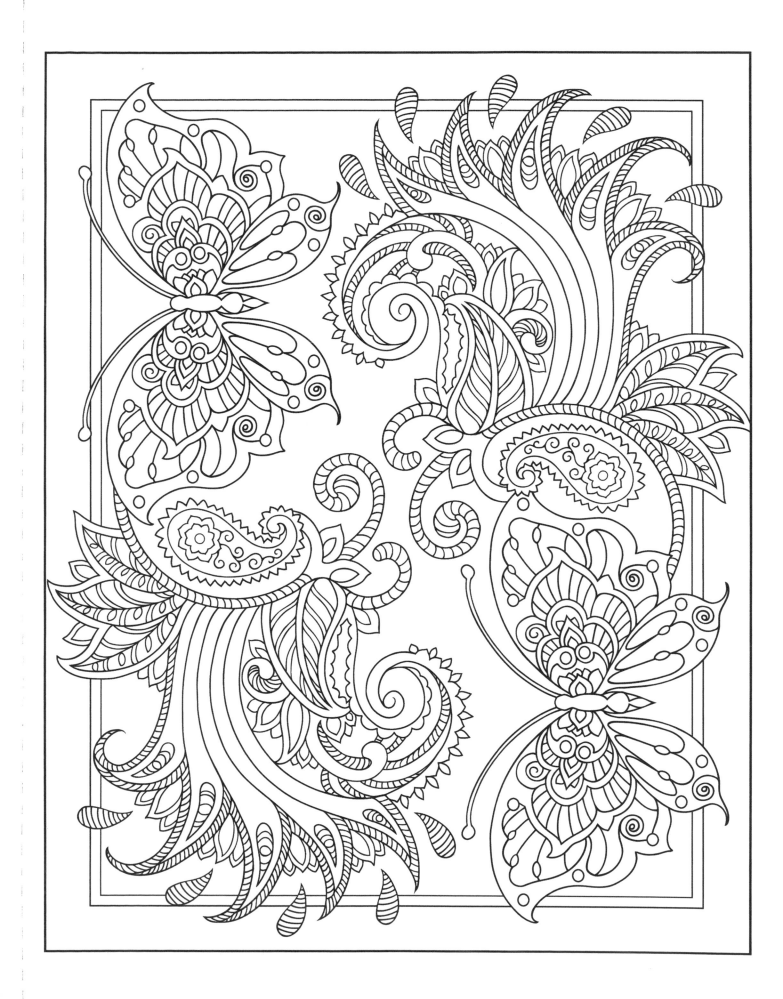

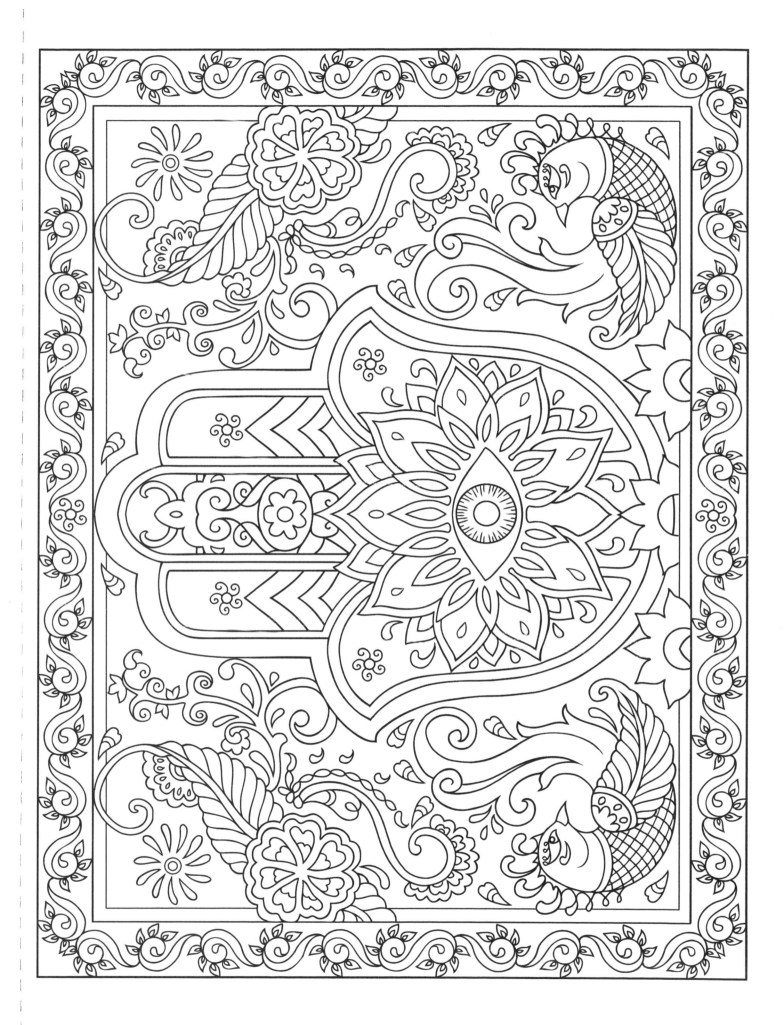